A–Z OF THE CITY OF DURHAM

Places - People - History

Andrew Graham Stables

AMBERLEY

Acknowledgements

Thanks to my family, the publishers and the good people of Durham who made every visit to the city a pleasure. Also thanks to the Facebook group 'Images of County Durham', especially the contributions of Robin Airton and Shaun Howey.

To the members of my father's lost family who worked the Durham coalfields from the 1860s until they closed

First published 2019

Amberley Publishing
The Hill, Stroud, Gloucestershire, GL5 4EP
www.amberley-books.com

Copyright © Andrew Graham Stables, 2019

The right of Andrew Graham Stables to be identified as the Author of this work has been asserted in accordance with the Copyrights, Designs and Patents Act 1988.

ISBN 978 1 4456 8407 9 (print)
ISBN 978 1 4456 8408 6 (ebook)

All rights reserved. No part of this book may be reprinted or reproduced or utilised in any form or by any electronic, mechanical or other means, now known or hereafter invented, including photocopying and recording, or in any information storage or retrieval system, without the permission in writing from the Publishers.

British Library Cataloguing in Publication Data.
A catalogue record for this book is available from the British Library.

Origination by Amberley Publishing.
Printed in Great Britain.

Contents

Introduction	4
Antony Bek, Bishop of Durham	5
Bede, Father of English History	9
Cuthbert	12
Dunholme, Duresme, Durham	17
Elvet	19
Framwellgate	22
Gilesgate	24
Hegge, Robert	27
Ignatius Richard Frederick Nemesius Bonomi	28
John Balliol	31
Kepier Hospital	33
Light Infantry	36
Miners' Hall	39
Neville's Cross, 1346	41
Old Durham	45
Prince-Bishops	47
Queen's Court, Queen Street, North Bailey	55
Racecourse	57
Smallpox Hospital – Vane Tempest Hall	59
Town Hall and Guildhall	61
University Library, Former Exchequer Building	64
Victoria Inn	66
Wear, Wardeleau and Wharton Park	73
Xtra-ordinary Stories from Durham	77
Yellow and Blue, the Colours of the County Durham Flag	86
Zululand	88
Select Bibliography	96

Introduction

This book is not the definitive A to Z of the city of Durham, nor is it a series of road maps to assist with your navigation of this astoundingly historic and World Heritage listed city, but I hope to bring you a selection of historical events, people and places who have helped to create the character of this fascinating place. It includes stories from the past, organised into an alphabetical order and chosen because they either piqued my interest or I felt were essential to the story, and I hoped they would you too. Some are well known and some are a little less familiar, but all are a crucial part of the Durham story. Even the name of the city evolved over time, and it is thought to originally derive from the Saxon for hill (Dun) and from a term for a raised islet surrounded by a river (Holme) with the Norman name Duresme becoming, by corruption, Durham.

The format and size of the book make it easy to carry around with you while exploring the city and I would suggest a steady pace is maintained up and down the hills. Make sure you partake in the food and drink on offer at one of the many hostelries who ply their trade in the city. I will, of course, be including many of the events associated with the cathedral, a World Heritage Site listed by UNESCO in 1986, which includes one of Europe's greatest medieval buildings, and the Shrine of St Cuthbert, one of England's most revered saints. This magnificent building also contains the burial site of Bede, considered to be the father of English history, and his works are still used today for the research into early Christianity.

This book will not give a complete picture of Durham's enthralling history, but that was never the intention. What I have included are some historical maps and locations, or suggested other nearby attractions of interest, but most of all, I hope that you will find the book interesting and an entertaining read.

Above left: John Speed map of Durham, *c.* 1611.

Above right: View of Durham Cathedral, 1834.

Antony Bek, Bishop of Durham

Anthony Bek was Bishop of Durham between 1284 and 1310, and was one of the most influential in the long history of the bishopric. He was responsible for building the Great Hall at Durham Castle and built Auckland Castle, at Bishop Auckland, which became the bishop's residence. He was also bestowed with the title of Patriarch of Jerusalem, which in theory gave him precedence over the Archbishop of York and Canterbury. He was buried within the cathedral, in the Chapel of the Nine Alters, and there was even an unsuccessful attempt to have him canonised. He was the son of a knight, born in Eltham in south-east London and educated at Oxford, and though destined for the Church, he was more of a warrior than a churchman. He served Henry III, followed by Edward I, who had crusaded together before Edward became king and Bek was a key player in Edward's efforts to command Wales and Scotland.

Durham Castle built on a motte.

Bek had only been Bishop of Durham for two years when in 1286 Alexander III of Scotland died, leaving a succession crisis where his only heir was a young granddaughter called Margaret of Norway. Bek acted on behalf of the Scots and for Edward to negotiate her marriage with the Prince of Wales, but tragedy was to strike when in 1290 the young Margaret died. She was sailing from Norway to Leith but violent storms drove the ship off course and she landed at South Ronaldsay on Orkney. It must have been a rough passage as Margaret died at Orkney, supposedly from the effects of a severe bout of seasickness. The poor girl was only seven years old. Edward was a wily old king, and it was at this point that the Scots asked Edward I to mediate with all the various claimants to the throne, but this would also allow Edward to influence the proceedings and gain some control over the final choice. The meeting took place at Norham Castle, an extremely imposing fortress on the Scottish border overlooking the River Tweed, and the attending Bek was recorded as looking the part of strong negotiator, with the churchman wearing a sword and adorned with clothes covered with jewels. The eventual choice was John Balliol, who owned land in Scotland, England and France, but as lord of Barnard Castle in the county of Durham, he was also a vassal of Bek, who had a major role in his coronation in 1292 at Scone.

Norham Castle.

Edward now expected to hold great sway over the new Scottish king, but Balliol refused to pay homage to Edward as his overlord, and when Edward demanded Scottish troops to support his war against France, Balliol not only refused, but formalised a mutual defence agreement with Philip IV of France against England. Bek and the Earl of Surrey commanded an army against the Scots and won the Battle of Dunbar in 1296, taking Balliol into custody and stripping him of his powers. It was at this time that Edward took the Stone of Scone, where tradition dictated the Scottish kings were crowned, and took it to Westminster Abbey to be placed under the English throne.

The next issue for Bek occurred the next year in 1297, when the Scots, with William Wallace and Andrew de Moray, defeated an English army at Stirling Bridge. The English commander was John de Warenne, and though he was an experienced warrior, mistakes were made when the English crossed a narrow bridge. With the boggy ground unsuitable for the heavy cavalry, the main body of the army remained on the other side of the narrow bridge so the English could not bring their superior numbers to bear. This evened up the battle and with all the fury the Scots could muster they pushed the English back, who panicked and those not killed retreating over the bridge were pushed into the river. It is thought the bridge was destroyed by the English to prevent the Scots from following them, which gave John de Warenne a chance to retreat with what was left of his forces. Wallace then raided the north of England, including the towns of Corbridge, Hexham, Durham and Carlisle, taking the spoils of war with him, hoping to draw Edward and his army north. Edward and Bek were actually in Flanders, and returning to England with great haste, they were ready to ride out from Durham by the summer of 1298 and take on the Scots under Wallace. Bek even led his own force, consisting of 140 knights and 1,000 foot soldiers, who were raised from the Palatinate, and all under the banner of St Cuthbert. Eventually the English army met the Scottish at Falkirk where they defeated them, and Wallace, now a fugitive, fled abroad before later returning to Scotland where he was betrayed by his own, captured and subjected to a traitor's death only seven years after his great victories.

Following the Scottish campaign Bek turned his attention to the bishopric, but there were those who questioned his commitment to the role and suggested he was more concerned 'with the business of the Kingdom than the affairs of his Bishopric'. Though a previous supporter of the prior and monks of Durham, he found himself in dispute with them and demanded the monks elect a new prior, but they stubbornly refused. Bek actually besieged the cathedral and priory to enforce his will, and though the surrounded monks bravely held out for three days on extremely meagre rations, Prior Houten was seized and imprisoned.

Houten somehow escaped and managed to obtain support from the king, probably because he was angry with Bek who had refused to support him in a dispute with the barons. Though Houten obtained favour from the pope, Bek appealed and was

forced to go to Rome himself, with the pope eventually taking Bek's side. The king was angered and would not let this lie, which resulted in a new hearing in England, where he reinstated Houten. It was at this time that the new pope, still supporting Bek, made him Patriarch of Jerusalem, but the death of Houten as he returned from Rome effectively ended the dispute, and although a new prior was found, there was no real reconciliation between Bek and the king. Edward I died in 1307 and it was his son, Edward II, who restored Bek to his former royal favour for the last few years of his life.

When he died in 1310, he was given the honour of a burial within the cathedral. Bek was a true prince-bishop, more of a warrior and protector of the north than a religious leader, and his support during the reign of one of the most warlike kings of England singles him out as an influential character. His buildings still stand testament to his wealth and influence.

Durham Cathedral.

Bede, Father of English History

St Bede, also known as the Venerable Bede, may have actually been called Beada, and is regarded as the most scholarly of the Anglo-Saxon historians. His works deal with theology, observations of nature and history, though his greatest work is considered to be Historia Ecclesiastica Gentis Anglorum or the Ecclesiastical History of the English People.

Bede is believed to have been born in Monkton, Durham (part of Northumbria at the time), but there is no record of his very early life or family background. When he was seven years old he was entrusted to the care of Benedict Biscop, who in AD 674 had founded the monastery of St Peter at Wearmouth. Just a few years later, in AD 682, Bede moved to St Peter's twin monastery at Jarrow where by the age of nineteen he had become a deacon, and was promoted to priest at thirty. He spent the rest of his life surrounded by the many books and manuscripts that had been collected from many different sources from all over the country.

One criticism of Bede is that he wrote about the history of the English, but never moved from the monasteries of Wearmouth and Jarrow where he wrote or translated around forty books about the bible, observations of nature, music and poetry, as well as history. His most famous work, the Historia Ecclesiastica Gentis Anglorum is considered a key source for the understanding of early British history and the arrival of Christianity. Though criticised for his lack of travel, he was at the centre of a hub of learning and may have sought information from many of the travellers who no doubt came to the monastery. He completed this work over his lifetime, finishing it in AD 731, and significantly it was the first work of history in which the Anno Domini system of dating is used.

His writings are a major source of reference regarding the early values of Christianity and how they were integrated within an intensely violent and warlike culture at that time. The Ecclesiastical History was completed 'towards the end of his life and dedicated to King Ceolwulf of Northumbria'. He left a comprehensible record of early Christianity in England, but it also encompassed a story of the foundation of the church, the royal families and a story of these lands from a time when records of this quality are scant.

It is said that Alfred the Great, almost 150 years later, took Bede's idea of a single English nation under one ruler to its final conclusion, and under his religious beliefs, he united the country under the teachings and laws of the church. Alfred referred to his people 'not as Saxons but as Angelcynn meaning Englishkind' and translated the works of Bede, written in Latin, into a language called 'Englisc'.

In May AD 735, Bede died in his cell at the monastery, but his books remained enormously popular and were copied by other houses, and even circulated around Europe. In 793 came the first recorded Viking raid on the north-east coast and over the following years the area was repeatedly ransacked, including the monasteries of Wearmouth and Jarrow. The remains believed to be those of Bede were discovered in the eleventh century and transferred to Durham Cathedral in 1022. They were brought from Jarrow by a monk called 'Elfrid the sacrist', who had them buried alongside the tomb of St Cuthbert. Later, in 1370, they were removed at the solicitation of a monk named Richard of Barnard Castle, and deposited in the Galilee Chapel. At the time of the Reformation, Bede's shrine was defaced and the bones were buried in the ground,

Cathedral cloister.

on which the shrine had stood, then covered by a large stone. In 1830–31 the tomb was first examined about the surface, and a few abbey pieces as well as coins were discovered. Then in the presence of various dignitaries, more abbey pieces were found as the workmen excavated to a depth of about 3 feet before they came in contact with human bones. The bones were incomplete but had been arranged in their respective places in a coffin of around 6 feet in length and included the skull, jaw bone, leg and arm bones and even some of the tarsi from the feet. In the upper part of the grave was a ring of iron, plated with a thick coat of gold, and was lined internally with one or two folds of thick woollen cloth, as if made to fit a hand. No remains of the hand were found and this ring, along with all the coins found in the grave, were placed in the library. The bones, including a memorial upon parchment of the particulars of the exhumation, were reinterred in a box of oak covered with lead and the upper slab of the tomb carefully replaced with the inscription:

HIC SUNT IN FOSSA BEDAE VENERABILIS OSSA
'Here are buried the bones of the Venerable Bede'

Bede is considered to be the 'Father of English History', and he rests in the cathedral in the city of Durham.

View of Durham, 1787, from the W. Hutchinson *History of the County Palatine*.

Cuthbert

The Conqueror, on this occasion, desired to see the body of St. Cuthbert, vowing, at the same time, that if he had been deceived in the relations he had heard of the incorruptibility of the saint's remains, and if the body was not found in the state represented to him, he would put to death all those of superior rank throughout the city who had presumed to impose on him. These menaces terrified all who heard him; but the king, determined to satisfy his curiosity, immediately ordered the officers of the church to open the sepulchre. Whilst he stood by, however, he found himself smitten on a sudden with a burning fever, which so distracted him that he rushed out of the church, leaving untasted a sumptuous banquet which the ecclesiastics had prepared for him, and instantly mounted his horse, and fled from the city with such haste that he never abated the speed of his courser till he had crossed the Tees. This supposed preternatural interference is said to have overawed the people, and to have contributed largely to the veneration paid to the saint's shrine.

(Account credited to Symeon (or Simeon) of Durham who was an eleventh-century English chronicler and a monk of Durham Priory.)

St Cuthbert is fundamental to the history of Durham and his story is the key event in the growth of this beautiful city, a city containing one of only seventeen UNESCO World Heritage sites in England.

Cuthbert was a prominent religious figure who lived from 635 to 687, and was Prior of Melrose, followed by becoming Prior of Lindisfarne. He was a successful preacher and church leader who had a significant impact on the spread of Christianity in the north of England. It was in death that he had an even greater influence on the Christianity when eleven years after his death, it was discovered that Cuthbert's body was incorrupt (showed no signs of decay) and this, combined with a series of miracles associated with the shrine, led to an increased belief in the cult of Cuthbert and Christianity. One of the most important English saints, especially when his body was brought to Durham in 995, his shrine became the most important holy pilgrimage in early medieval England and remained so until the death of Thomas Becket in 1170.

During his life, Cuthbert was a preacher and hermit who embodied the values of humility, simplicity and tolerance. Due to the cult of Cuthbert, one tradition recounts he was the son of an Irish king, and another said that he was born local to Melrose because he guarded sheep on the hills above Melrose Abbey as a child. The monks at the nearby Melrose Abbey may have been an inspiration and one tale tells of a vision he had of a soul being carried to heaven by angels. The next day he learned of the death of St Aidan, the very first Bishop of Lindisfarne and an influential religious leader. He did not immediately join the order at Melrose and instead spent several years as a soldier in a time of upheaval between Northumbria and Mercia. When he finally joined the Melrose order he quickly earned a reputation of devotion and humility, so much so when a monastery at Ripon was founded, he was chosen to be its master.

In 661, following a split in the church between the traditions of Celtic rite and the Roman rite, he chose to return to Melrose and the Celtic rite, but only three years later; when Prior Biosil of Melrose died, Cuthbert was chosen as his successor. Within a few months of his appointment, at the church meeting in 664, known as the Synod of Whitby, the Roman rule was adopted and Cuthbert accepted the synod's decision. His skills were then required to ease the transition from Celtic to Roman rule when he was sent to the Priory of Lindisfarne and became renowned for his tact and patience during the changes he was now charged to oversee.

Perhaps the strain of the conversion took its toll and in 676 he was granted leave to take up the simple life of a hermit and a life of contemplation. It is uncertain where he chose to live a life of solitude and some say it was the small rocky outcrop called St Cuthbert's Island, near Lindisfarne, but others say it was St Cuthbert's Cave, near Howburn. Whichever is the truth he soon moved to Farne Island, just opposite Bamburgh and the fort which would have occupied the site at this time.

Lindisfarne and the priory.

Following his years of contemplation on the island, Cuthbert was persuaded to end his retirement from the church and reluctantly became Bishop of Lindisfarne. His consecration was held at York on Easter 685 after which he returned to Lindisfarne, but at Christmas 686 he felt his end was near, resigned his position and returned to Farne Island where he died in March 687. He was buried on Lindisfarne, but this is not where his story ends.

For some reason in 698, his tomb was reopened and it was discovered that his body had not decomposed in any way. This was considered to be a sign of his dedication to the church and his piety, leading to his tomb becoming a site of pilgrimage. Many miracles were reported at his grave and as a result he was canonised as a saint, and the cult of St Cuthbert began to grow.

Within a hundred years the north-east coast was subject to a seismic event when in 793, Lindisfarne Monastery was attacked by raiders from across the North Sea and raids by the Vikings would become a frequent occurrence over the next few decades. The monasteries were easy prey to these ferocious attackers and usually contained great wealth but were poorly defended. Their raids into England were fairly sporadic until the mid-800s, but soon they began to stay longer and in greater numbers. By 866, they captured York, followed by the southern part of the kingdom of Northumbria, and during this period the records from many monasteries come to an end. In the 870s the Vikings moved further into England and almost took over the whole country, and it was in 875 that the monks of Lindisfarne decided to flee. They took with them what remained of the monasteries wealth, which included the relics of St Cuthbert and the Lindisfarne Gospels.

St Cuthbert's coffin.

The story is they wandered the countryside for seven years (and many places in the north of England claim to be somewhere they rested) until a Danish king, possibly Gothfrith, who had already converted to Christianity, gave them land in Chester-le-Street. They settled inside the Roman fort, known as Concangis, and built a church where they remained for 113 years. The site at Chester-le-Street became the shrine for the pilgrims who included many kings, including Athelstan who is said to have given then an ornate bible, now lost and possibly destroyed during the reformation.

However, in the 900s as further Viking danger threatened the body of Cuthbert was moved again, this time to Ripon, but for only a few months before trudging back to Chester-le-Street. During this journey, the legend tells of the cart carrying the coffin suddenly stopping and the monks could not move it any further. The leader of the order, Bishop Aldhun, revealed he had had a vision of St Cuthbert's desire to be taken to 'Dunholme', but nobody was familiar with this name. As the monks could not move, they rested by the road when a cow girl walked by, and asked another young woman if she had seen a 'dun' (can mean 'brown') cow she had lost. She replied she had, and pointed out she had seen it heading for Dunholme, the monks overheard and followed the cow girl with Cuthbert's cart, which moved only in that direction. They finally ended up at Durham.

This legend was probably the creation of Bishop Aldhun, who manipulated the situation to suit his own ends. His daughter had married Uchtred, the new Earl of Northumbria, and part of the marriage deal included extensive land for Aldhun and the Church in Durham. From a practical point of view the site was perfect for defence, being raised land, with steep banks, above a natural loop in the river. It could be described as a natural moated castle built by God. It was here the community built the first church and shrine that was eventually to become Durham Cathedral.

Above left: Dun cow.

Above right: Dun cow looking towards the cathedral.

Left: St Oswald's Church.

Below: St Oswald's graveyard.

D

Dunholme, Duresme, Durham

'Dun' can mean 'brown' or 'dun' can mean 'hill' or 'fort' in Old English, and 'holme' usually means a slightly raised islet in a fen or partially surrounded by a stream or river in Anglo-Saxon and Scandinavian. So if Durham was an Anglo-Saxon town called 'Dunholme', 'Dunelm' or 'Dunholm', depending on which spelling you prefer, perhaps this is best translated as a hill island surrounded by a river, which in this context seems to be very apt description. It must be said that there is little documentary evidence for the town before 995 from when Cuthbert was brought to the site and it has also been suggested that the community of Cuthbert may have first settled across the river at a site occupied by St Oswald's Church. St Oswald's may be the oldest of

Elvet Bridge.

Durham's parish churches based on the collection of Anglo-Saxon sculptured stones discovered in the walls of the church and churchyard. The site has a circular-shaped churchyard on early maps, which is a sign of an early site and the dedication to St Oswald, a seventh-century Northumbrian warrior king, also backs up this theory. Durham is not mentioned in the late 800s by King Alfred in his division into shires, hundreds and tithings of the counties, and neither do Northumberland and Durham appear in the Domesday Book of 1086. However, we do know the Norman's gave this place the appellation of 'Duresme', of which its present name Durham is a corruption, and records show that even during the reign of Edward III (1327–77) Durham is still referred to as Duresme following a Scottish raid into south Durham: 'Archibald Douglas toke great prayes in the Bishopriche of Duresme, and encountrid with a band of Englishmen at Darlington, and killed many of them.'

Elvet Bridge at dusk with a floral display.

Elvet

It may be that Elvet is the oldest part of Durham based on the position and name of St Oswald's Church, the 'Maiden Castle' or Iron Age fort on a promontory over the River Wear and according to the antiquarian Hutchinson it is conjectured that the Saxons settled here, as mentioned under the Dunholme chapter of this book, due to the shape of St Oswald's churchyard, the dedication to St Oswald and the Anglo-Saxon stones discovered at the church.

Maiden Castle is an Iron Age hill fort that stands on a promontory above the River Wear, and just behind Whinney Hill. Not easily seen until you are on the ground, the site stands some 100 feet above the surrounding three sides and is hidden by buildings on the west. It is protected on all but the west side by steep natural slopes and covers about 2 acres of land, which is now overgrown with a wood. The fort measures around 180 metres by 75 metres and where the natural defence is weak on the western side is a rampart over 5 metres wide and 2 metres high, with an external ditch, still 1 metre deep. On the southern some earthworks are still visible, while on the northern part of the site there seems to be an entrance in the original ditch.

Some excavations were made in the late forties/early fifties and discovered that it was originally constructed of clay embankments, which were covered with cobbles and finally capped with a wooden palisade. It was found that sometime later the inner side of the rampart had been removed and a stone wall was built, but afterwards wooden stakes were added to the wall for strength. There was evidence that these stakes were burnt when the fort was abandoned or destroyed. One of the more unusual discoveries was a medieval mason's mark in one of the stones used in the wall, which suggests the prehistoric hill fort was used for some purpose during the medieval period. None of the pottery finds from the site confirmed its age, with the earliest being around the fifteenth century.

Linking the Durham peninsula to Elvet is a bridge of the same name. Elvet Bridge was built around 1170 by Bishop Hugh Le Puiset and consisted of 8 arches, but was later repaired by Bishop Fox and increased to twice its breadth to cope with coaches in 1806. At one time the bridge incorporated two chapels, one dedicated to St James and the other to St Andrew, to allow travellers to pray for a safe journey. It was quite

a common feature on bridges throughout Britain in the fourteenth and fifteenth centuries, and they were often chantry chapels where prayers were said for the souls of the founders and benefactors of the bridge. They also provided a place for travellers and pilgrims to attend mass and pray for a safe journey.

Also within Elvet is Durham Prison, which over the years has incarcerated some of our most famous criminals, including the Kray twins, Rose West, Myra Hindley and John McVicar. Durham Prison is now located behind the court building but before this the city had two prisons, with the County Gaol situated in Saddler Street and the other known as old Bridewell or House of Correction, which was actually built under Elvet Bridge. The County Gaol was in the possession of the Bishop of Durham and was rebuilt in Saddler Street in the early fifteenth century, and although enlarged in 1773 it was still considered a squalid place by various leading prison reformers who visited the place.

Old Bridewell or the House of Correction was built in 1634 on the north side of Elvet Bridge to help reform beggars or vagrants by providing work and accommodation. These 'good intentions' soon disintegrated and the place began to be used as a common prison for the criminal overspill from the County Gaol. It was also a home for debtors, people due for transportation, men conscripted into the military instead of being executed, as well as lunatics and vagrants.

Tythe Barn, which is now part of HM Prison.

Old police station in Old Elvet.

Old postcard of Elvet Bridge, showing more arches.

Framwellgate

Framwellgate contains Durham's oldest bridge over the Wear and was constructed around 1127 by order of Bishop Flambard. This was a strategic entrance to the city protected by the castle above. Flambard also 'fortified the castle with a moat, strengthened the banks of the river, and built the beautiful bridge called Framwellgate'. The bridge also included a strong gateway and tower to guard against ingress into the heart of the city but was removed in 1760 when it was felt to be no longer required.

The bridge was damaged by floods in the fifteenth century and rebuilt by Bishop Langley, but during the great flood of 1771, the river rose so high it was claimed to be '8 feet 10 inches higher than ever known before' and two houses at the end of Framwellgate Bridge, with all the furniture, were swept away. The flood also caused extensive damage to the mills, some arches of Elvet Bridge and many of the lower buildings of the city. Some of the animals contained within byres and stables were drowned with the loss of 'several horses and cows', though no loss of human life was

Framwellgate Bridge and Castle.

recorded. One story included a lucky young woman who fell into the water as the riverbank gave way, and was carried 700 yards down the river until she was saved by the assistance of her work friend.

The medieval bridge would have been so much narrower than what we see today and would have been built on with shops as it was the ideal commercial location as people entered or left the city. The bridge was remodelled and doubled in width in 1859 to allow for the coaches and improved flow of traffic around the city.

Framwellgate Bridge and Cathedral.

Gilesgate.

Gilesgate

Gilesgate is a long, steeply banked street, and is still sometimes known by its medieval name of Gillygate, or the street of St Giles. Set back from the route of the modern road is the parish church of St Giles, who is actually the patron saint of the crippled, beggars and lepers. The church was part of the hospital of St Giles, which was founded and built by Bishop Rannulf Flambard in AD 1112. The tower is considered to be early thirteenth century with fifteenth-century belfry modifications and the obligatory Victorian additions to the south aisle and vestry, and north porch. Despite the Victorian changes, many Norman features remain including doorways, some windows in the north wall of the nave and some grave covers. There are two pre-Reformation bells as well as another dated 1640. The font in the tower is Norman and is made up of a large lead-lined bowl on a round pedestal with a cushion capital. It is thought to date from the twelfth century when the building became a parish church after the hospital buildings were destroyed.

St Giles' Church.

The hospital was in the vicinity of the church but was burned down in 1144 after trouble caused by one of the most notorious figures in the history of the bishopric of Durham called William Cumin. Cumin was a bishop who usurped the position of Prince-Bishop of Durham with encouragement from King David of Scotland with his own band of armed enforcers and fighting men. He had resided at Durham castle for three years, terrorising and threatening the local inhabitants, but his actions did not go unnoticed and William of St Barbara was elected as the true Bishop of Durham. William of St Barbara headed north supported by local barons, including Roger Conyers, to remove Cumin.

However, Cumin would not stand down or be intimidated by the real bishop and his followers, and held out at the castle, not allowing St Barbara entry. St Barbara took refuge at St Giles' Church. The next day Cumin broke his way into the church and a sword fight ensued between the rival supporters while the monks prayed for peace. Cumin came out on top with the element of surprise in his favour, and the real bishop was forced to retreat from Durham as the better part of valour. William of St Barbara determined to try again, enlisting the help of the Earl of Northumberland, and in August 1144 was successful. Cumin's men fled but not before he and his men had burned down the hospital of St Giles. Cumin was later captured by Roger Conyers at Kirk Merrington and relinquished his claims to the bishopric.

St Giles' entrance doorway.

The church survived this conflict and other incursions (especially during the wars with Scotland) and by the end of the Tudor period the country settled down to a period of peace. In the chancel is a wooden effigy of John Heath, Lord of the Manor of Gilesgate and church patron, who died 1591. He is shown in armour, with his head resting on a cock-crested helmet and his feet on a scroll containing two skulls inscribed 'Hodie mihi cras tibi', which can be translated as 'Today is mine; tomorrow, thine.' Another wooden structure, the oak screen, was erected in 1937 and was carved by Robert Thompson of Kilburn in North Yorkshire, also known as the 'Mouseman' because of his famous trademark mouse as carved into the screen.

Inside St Giles'.

View from Gilesgate, 1834.

H

Hegge, Robert

Robert Hegge, antiquary and writer, was born in Durham in 1599 (though some sources believe this to be 1597). He was the son of a respected lawyer and his wife, Anne, who was the daughter of a clergyman. He revealed his talent very early and at the tender age of fifteen he was admitted as a scholar of Corpus Christi College, Oxford, and was considered to be exemplary in mathematics, history and scripture. He graduated with a BA in 1617, followed by his MA in 1620 and in 1624 became a probationer fellow of his college. The career of this luminary was, however, cut short when he died suddenly on 11 June 1629 having only just reached the age of thirty. It is mentioned that he suffered a 'distinct deterioration in the year before his death', which is shown in his later work and letters before his death, when apoplexy is recorded as the reason for his demise. He was buried in Corpus Christi Chapel and commemorated by a tablet inscribed 'ROB. HEGGE, A.M. Soc. Jun. II, 1629'. This was moved to the cloister later that century, when modifications to the chapel were carried out in 1675–76, but was lost probably when the old cloister was pulled down and the new one built between 1706 and 1712.

Of all his work the significance of his Legend of St Cuthbert is of particular importance to Durham, his home town and the place he grew up. This book became the reference for many future antiquarians and is referred to fondly by Hutchinson among others.

St Cuthbert installation in Walkergate.

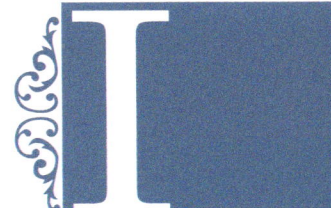

Ignatius Richard Frederick Nemesius Bonomi

Ignatius Richard Frederick Nemesius Bonomi (1787–1870) was an English architect and surveyor, whose influence on Durham and the north-east of England is still visible today. He was the son of Italian architect Giuseppe Bonomi, who came from Florence to England in 1767 to work for Robert Adam, a celebrated architect who brought in the 'Adam style', which was characterised by a 'new lightness and freedom in the use of the classical elements of architecture'.

Born in 1787 at No. 76 Great Titchfield Street, London, he moved to the north of England because of his father's work at Lambton Castle in the mid-1790s and trained in his father's office. Bonomi Snr had prepared three alternative designs (July 1794, August 1794 and February 1795) for the new Lambton Hall but the grand plans were abandoned with the death of William Lambton in 1797. Between 1798 and 1802 Bonomi carried out greatly reduced alterations to the existing house as Lambton's son and heir was not of age until 1813. In 1808, at the age of twenty-one, Ignatius had to take over the practice due to the death of his father and the business flourished under his direction. He continued to work on the transformation of Lambton Hall and in the 1820s John Lambton decided that the hall should have a grander appearance and began transforming the building into a castle. The design added turrets and battlements to instil the outward appearance of the building as a castle.

Bonomi attracted clients from the local aristocracy and clergy and was appointed surveyor of bridges in 1813. In 1824 he was responsible for Skerne Bridge (over the River Skerne, near Darlington), which is one of the first railway bridges in the world and was for the Stockton & Darlington Railway. This bridge holds a significant place in history as it is the world's oldest continuously operated railway bridge, and it was the largest piece of infrastructure on the world's first proper passenger railway. Not only that, but it used to feature on the back of the George Stephenson £5 note, which was in circulation between 1990 and 2003. Originally, George Stephenson was to build this bridge in iron and stone, but his first iron and stone bridge over the Gaunless at West Auckland was washed away, and the price of iron rose. This convinced the

company directors to seek the advice of Ignatius Bonomi, the well-known architect who was also the county bridge surveyor, and his plan for a three arch stone bridge over the river (a large arch in the middle and two small pedestrian ones on either bank) was built.

Bonomi was also responsible for a number of church buildings as well as commissions at Durham Cathedral and Durham Castle. He worked on Durham Prison, Elvet Hill House, Burn Hall and Eggleston Hall, and further afield he was also responsible for Marton House near Appleby-in-Westmorland, Blagdon Hall near Morpeth, the Church of St John the Baptist in Leeming, and the restoration of St Nicholas House and Aske Hall in Richmond for Lord Zetland.

On 27 December 1837, Ignatius married Charlotte Fielding, the daughter of Revd Israel Fielding of Startforth, near Barnard Castle. He was aged fifty and she was thirty. They were married at two churches: the first Anglican in Lanchester and the second Roman Catholic at St Cuthbert's in Durham; Neither wished to convert to the others religion.

In 1842, he entered into a partnership with John Augustus Cory, who was later Cumberland County architect and one of their projects was the highest church in England, St John the Evangelist at Nenthead. He retired around 1850 and left Durham to live near his brother in Wimbledon where he died in 1870 at their home and is buried with his wife in Paddington Cemetery.

Alington House was the home of Ignatius Bonomi.

The Durham County Court was built in 1814–21 and boasts its very elegant proportions, as designed by Ignatius Bonomi.

Durham County Courts, 1834.

The £5 note (1990–2003) showing Skerne Bridge.

J

John Balliol

The Balliol family were influential Norman lords of vast estates in France and England, including lands in south Durham and the impressive fortress at Barnard Castle. From the 1200s, the Balliol's were in the ascension when John de Balliol gained land and titles in Scotland through his marriage to Devorguilla of Galloway , and this allowed his son, John de Balliol II, to become a contender for the vacant Scottish throne in 1292.

The Balliol family had been in dispute with various bishops of Durham over lands in Sadberge, south Durham, where the bishops believed they were owed homage. John de Balliol raised the argument just after his inheritance in 1229 and the quarrel intensified after 1255, when various violent outbreaks took place. However, Balliol was serving as one of Henry III's English representatives in the Scottish government and this ongoing dispute did not serve the needs of the king, which finally led to Balliol's ultimate submission to Bishop Kirkham at Durham Cathedral in 1260. The understanding is that Balliol's penance was the foundation of Balliol College at Oxford University, although another theory associated with this atonement called for Balliol's youngest son, John de Balliol II, to be educated at a Durham school. The Balliols could have provided for a private schoolmaster or chaplain to educate John but clerical training was best done in a religious community.

Barnard Castle and the Balliol Tower.

John, as the youngest son, was not expected to inherit the great estates of the Balliol family and perhaps his father sent him to one of the clerical schools at Durham to enter the priesthood, a suitable occupation for a younger son of nobility. John and Devorgilla had nine children, four sons and five daughters but by the time of John's death in 1268, his son, John II, had survived his three older brothers to inherit his father's titles and estates. Accounts of the time suggest he was a pious man and not suited to the challenges expected of a mighty lord but soon his destiny would take a direction that would make him a significant figure in history.

It is likely that John was born at Barnard Castle in England, yet he was to become a king of Scotland due to the titles from his mother and the political ambitions of a king of England. Scotland was a continual problem for the English kings and when Edward I was asked to assemble the Scottish and English lords to adjudicate over who would be king of Scotland to avoid a civil war, they chose John de Balliol as the new king. Heavily influenced by Edward, and knowing John's nature, he felt he would be able to hold great sway over him. He swore loyalty to Edward, but surprisingly, once in power, he rejected the authority of the English king. By 1296, this resulted in Edward marching north with an army, and John was forced to surrendered his right to the Scottish throne and imprisoned in the Tower of London. All of his English estates were confiscated, although he was later allowed to retire to his family estates in Picardy. John, the English king of Scotland, is thought to be buried in the Church of St Waast, at Bailleul in France.

Above left: Barnard Castle inner keep and the River Tees.

Above right: Priory entrance from North Bailey.

Kepier Hospital

All that remains of Kepier Hospital is the gateway, a well-built stone structure with pointed arches, and some farm buildings that may incorporate some medieval core within the later construction. The hospital is believed to have been founded by Bishop Flambard in 1112 with an endowment for the maintenance of a master and twelve brethren. The hospital was situated on the banks of the River Wear in the parish of St Giles, though nothing of the twelfth century survives above ground and the remaining gatehouse is mainly fourteenth century in construction. The site also includes a mill and a mansion but as the mill ceased to be used, the site fell into ruins and parts were demolished.

During the reign of King Stephen (1135–54) much of the site was destroyed by fire but Bishop Pudsey restored the buildings around 1180, including an infirmary, dormitory and church dedicated to St Mary and All Saints. The remaining gatehouse, built by Bishop Bury in 1341, is described as a 'fine buttressed gateway' that leads to a courtyard on the opposite side where a farmhouse is believed to be a fourteenth-century building partly on twelfth-century foundations. The water-powered corn mill burned down in 1870 and very little remains of the mill, weir or the race. A service trench was cut in the

Keiper Hospital gatehouse view.

orchard behind Kepier Hospital in 1961 and revealed foundations of some medieval buildings as well as possible precinct boundary walls and a burial ground.

After the Dissolution of the Monasteries, in 1545–46, Keiper was granted to Sir William Paget by Henry VIII, whom he served in various diplomatic roles. A John Heath purchased the property in 1568, who later built a mansion house with pleasure gardens and a loggia (garden terrace) that can still be seen.

It was owned later by a Ralph Cole Esquire followed by the families of Tempest, Carr and Musgrave.

Left: Keiper Hospital gatehouse.

Below: Keiper Mill, *c.* 1780, from Hutchinson's book.

K

Above and below: Remains within the grounds of Keiper.

Light Infantry

The Durham Light Infantry has a long and distinguished history, from when the regiment was originally formed in 1758, and the 2nd Battalion of the 23rd Regiment of Fusiliers changed designation to the 68th Regiment of Foot. They first saw limited action during the Seven Years War (1756–63) by raiding the French coast in support of Britain's ally Frederick the Great of Prussia, and between 1764 and 1806, the regiment was regularly posted to the West Indies during the colonial expansion and French Revolutionary War period.

DLI Chapel within the cathedral. (Photo by kind permission of Shaun Howey)

In the early part of the nineteenth century the 68th Regiment of Foot trained as Light Infantry, to provide a skirmishing screen ahead of the main body of infantry in order to delay any enemy advance, and served with distinction during the Peninsula War (1808–14) fighting at such renowned battles as Salamanca, Vittoria, and Orthez. The next major conflicts for the regiment were the Crimean War (1853–56) and were involved in the battles of Alma, Inkerman and Balaklava, where Private John Byrne and Captain Thomas de Courcy Hamilton were awarded the Victoria Cross.

In 1881 the Durham Light Infantry was formed from the 68th and 106th Regiment of Foot (originally an East India Company Regiment) and the new regiment soon saw action in Egypt and against the Boers in South Africa. The South African War memorial is stood outside the cathedral on Palace Green to commemorate the soldiers of the Durham Light Infantry who gave their lives in the Anglo-Boer War (or South African War) in 1899–1902.

The next major conflict took men from the mines, shipyards, farms, schools and offices of County Durham and though the First World War began with volunteers, conscription soon took young men away from their homes and families. The DLI raised forty-three battalions, including the Durham Pals, many of who saw active on the Western Front, Italy, Egypt, Salonika and India. The DLI on the Western Front were involved in such infamous battles as Ypres, Cambrai and the Somme to name but a few. The regiment served with such distinction that they were awarded sixty-seven battle honours and won six Victoria Crosses, but lost 12,530 men in the process. Thousands more were wounded, gassed or taken prisoner, and would have suffered greatly after the war, with the true cost to these young lives being unmeasurable.

The six soldiers awarded the Victoria Cross during the Great War were Thomas Kenny, Roland Bradford, Michael Heaviside, Frederick Youens, Arthur Lascelles and Thomas Young.

During the Second World War the DLI fought in every theatre of war including Dunkirk, North Africa and Italy, Burma and from the Normandy landings across Europe until the defeat of Nazi Germany in 1945. The casualties during the Second World War were not as numerous as the First World War but the troops still suffered heavy losses at significant battles during the period. As early as May 1940, Captain Richard Annand became the very first soldier of the Second World War to attain the Victoria Cross. His efforts to halt the German advance through Belgium and his rescue of a fallen man were an example of bravery that warranted the awarding of the highest honour given by this country.

After the war the regiment was greatly reduced but continued to serve in the Korean War, Cyprus and Berlin, usually as part of a peacekeeping force. In 1968, it was announced that the Durham Light Infantry would be amalgamated with the Somerset and Cornwall Light Infantry, the King's Own Yorkshire Light Infantry, and the King's Shropshire Light Infantry to form the Light Infantry Brigade. On 12 December 1968 in Durham Cathedral, the DLI paraded their colours for the last time and after 200 years of fine service to the country, the regiment was no more.

A–Z of the City of Durham

In 2007, further consolidation of the Light Infantry with the Devonshire and Dorset Light Infantry, the Royal Gloucestershire, Berkshire and Wiltshire Light Infantry and the Royal Green Jackets led to the formation of the Rifles Regiment.

DLI monument in the Market Place.

Miners' Hall

The county of Durham is well known for its coal mining industry – indeed my own family were associated with mining here for at least 100 years – and the Miners' Hall, known as Red Hills, is regarded as one of the finest purpose-built trade union buildings in Britain. Built in 1915, Red Hills looks more like an educational facility or a hospital and is a statement to the size and status of this once vibrant industry. It is still the headquarters of the Durham Miners Association and was actually the second miners' hall in the city, with the first smaller headquarters being located in North Road. The expansion to Red Hills was inevitable as the industry boomed after the turn of the century and membership of the association rose to over 150,000 people.

Durham Records Online highlight how important coal was to the region when you look at the population of County Durham in 1801, which was just 150,000, and over a third lived in the ancient towns of Hartlepool (1,047), Barnard Castle (2,966), Stockton (4,009), Darlington (4,670), Durham (7,500), Gateshead (8,597), South Shields (11,000) and Sunderland (18,000). By 1901 the population of County Durham had increased to around 1.88 million due to the demand for coal in a burgeoning industrial world.

The Durham Miners' Association was founded by liberal Methodists in 1862 and developed into a political force from which the Labour Party rose, but they were also socially responsible by building houses for retired miners, welfare halls, libraries and hospitals in many of the pit villages. The coal industry in County Durham peaked in the early 1900s when 250,000 mineworkers were employed but the last mine in the county closed in 1993. My own family lived in various locations around Durham including Newbottle and Hetton-le-Hole, and I know they worked at the Hetton Lyons Pit for a good number of years.

One of the outstanding rooms at Red Hills is the Council Chamber also known as 'The Pitman's Parliament', which still hosts different events and meetings. Originally made up of seating for over 400 delegates, which was arranged in a circular pattern, the hall is planned to be reinvigorated as a venue for art and music. It is considered a vital part of the regional heritage as is reflected in the Durham Miners' Association motto 'the past we inherit, the future we build.' Red Hills, at the time of writing, was in need of refurbishment and many supporters have been brought together to

try to secure the future of this impressive and still useful building. Outside of the building and visible if ever you take the train to the south of Durham station are some fine statues of various mining leaders including W. Crawford, A. Macdonald, W. H. Patterson, and J. Forman. Among the more unusual artefacts contained within the hall is a telegram from Joseph Stalin thanking the Durham miners for the donation of an X-ray machine, as well as posters of Che Guevara, all of which makes the hall a must-visit place.

Red Hills Hall.

Old postcard of the Miners' Hall.

N

Neville's Cross, 1346

On 17 October 1346, on moorland to the west of the city of Durham a clash between the Scottish and English armies known as Battle of the Red Hills was fought. This encounter is more commonly known as the Battle of Neville's Cross.

Neville's Cross.

While Edward III was engaged in the ongoing struggle with France known as the Hundred Years War, and his great victory over the French at Crécy in August 1346, the English continued this success by besieging Calais. Philip VI of France, in an attempt to divert the Edward's army, asked his ally David II of Scotland to attack England from the north. David assembled one of the most powerful armies to ever cross the border and invaded England via the western marches. The Scots first fell upon the little pele tower of Liddel Strength near the Scotland–Cumbrian border and destroyed the defence and beheaded the commander on the spot. They advanced to the Abbey of Lanercost, burning part of this religious house before moving on through Cumbria and down Tynedale. Next they sacked the Priory of Hexham, but spared the town in order to serve as a store place for their intended plunder from more towns and cities along the route. After crossing the Tyne and Derwent, David halted at Ebchester, and the next day encamped, without meeting any serious opposition, at the Bishop of Durham's great deer park at Beaurepaire (Bearpark).

Unknown to David the English, commanded by Ralph Neville, 2nd Lord of Raby, Henry Percy and William Zouche, the archbishops of York, Durham, Lincoln and Carlisle, hastily assembled an army of 16,000 men and joined up at Auckland Park, approximately 10 miles from the Scottish camp. On 17 October, the English marched towards the enemy looking for higher ground and halted at Kirk Merrington, from where the movements of the Scots could be observed. The army carefully proceeded towards Ferryhill where a strong foraging party of the Scots under William Douglas were taken unawares, and a skirmish in the early morning mist drove the Scots off, resulting in heavy Scottish casualties.

The English moved forward to the high grounds above the Wear and slowly formed into their order of battle with Durham on the right near a position called Red Hills. In the meantime, William Douglas had escaped from his pursuers and reached the Scottish camp to tell of the approaching English force and advised a retreat to the hills to avoid an engagement but this was rejected out of hand.

The Scots advanced to meet the attack but the English had already secured the better position as the Scots formed in to three divisions, the first Scottish division led by King David, the second by John Randolph, earl of Moray, and Sir William Douglas and the third by the king's nephew, Robert Stewart, earl of Atholl and also High Steward of Scotland. The English distributed their force in four bodies, with Lord Percy commanding the first, Lord Neville the second, Sir Thomas Rokeby, sheriff' of Yorkshire, the third and a strong body of cavalry under Edward Balliol formed the reserve. It was said Prior John Fossor of Durham had a vision telling him to take the corporeal cloth (used to cover the host during the Mass) of St Cuthbert and take it to the Maidens Bower near the site of the forthcoming battle. The cloth was elevated on the point of a spear within sight of both armies as it was important to show God was on the side of the English and the legend of St Cuthbert held great sway.

It was said the City of Durham awaited with great suspense the outcome of the battle, as the city was a prize for the conqueror, and the 'remaining brethren of the convent poured forth their hymns and prayers from the highest towers of the cathedral', obviously anxious to learn the outcome of the combat. There seems to be a few different accounts of the details of the battle but most agree that as the Scots were encouraged to attack, the English archers disrupted their formations and initially the invaders, under great pressure, managed to break forward and push Lord Percy back. It was the reserve cavalry under Balliol who may have been decisive when they 'made an impetuous charge on the high steward's divisions, and drove them from the field'. King David was at the same time engaged in a stalemate against Lord Neville until Balliol, forcing the high steward to retreat, now wheeled around and threw himself on the flank of David's formation. As their position grew more dangerous, the Scots began to panic and fled the battlefield, but David continued to fight despite having two arrows in his body.

The Scots were disadvantaged by the uneven landscape, superior position of the English and the devastating hail of arrows from the archers, which allowed the English to cope with the Scottish attack. The legend says David initially managed to escape capture but he was discovered hiding under a bridge over the River Browney near Bearpark, when his reflection was spotted in the water by English soldiers who were searching for him. He still resisted several attempts to take him captive but was compelled to surrender to John Copeland, a Northumbrian esquire, two of whose teeth he smashed out with his clenched steel gauntlet. There is a story he was imprisoned at Richmond Castle in North Yorkshire for a while before being imprisoned at Odiham Castle in Hampshire from 1346 to 1357. After eleven years, he was released in return for a ransom of 100,000 marks.

Besides the king, the earls of Fife and Monteith, as well as Sir William Douglas, were made prisoners, but more devastating were the losses to the Scottish nobility including the earls of Murray and Strathmore. Of the English leaders only Lord Hastings fell. The figures of Scottish dead vary from 15,000 to a few thousand but the difference between these and the English losses was huge. After the battle, the prior and monks, accompanied by Ralph Lord Neville, John, his son, Lord Percy and many other nobles, proceeded to the cathedral in a thanksgiving to God and holy St Cuthbert for the conquest obtained that day. Where they had held aloft the corporeal cloth of St Cuthbert an elegant cross of stone was built to commemorate the battle, all at the expense of Ralph Lord Neville, which was afterwards known as Neville's Cross.

Most of the battlefield is now developed, though the area around Crossgate Moor where some of the action is thought to have taken place is still undeveloped.

Neville's Cross behind the railings.

Old Durham

Old Durham is the name of a farm a mile to the east of Durham and is believed to be the site of the most northerly Roman villa in England. The discovery of old bridge piers had been taken as evidence of a Roman crossing over the River Wear and the theory was further substantiated when the remains of a Roman bathhouse were found at Old Durham in 1940. Excavations at Old Durham reveal a second-century Roman villa or farmstead that stood on the low-lying ground, south of the farm near the north-east side of the beck, close to the footbridge. References to Old Durham first appear in the twelfth century and it is possible the ruined bathhouse was still visible in Norman times, acquiring the name 'Old Durham'.

Thought to be a civilian site rather than a military one, it is understood to have been occupied in the second and fourth centuries but abandoned for some reason during the third century. It is likely the estate was British in origin but became more Romanised during the years of occupation and would have housed an important local family. They may have also diverted the course of the Old Durham Beck around the estate to join the River Wear further north, maybe for defensive purposes or just to serve as irrigation for the land. The site may have fallen into disrepair over the following centuries but in 1268 records state there was a manor house here.

The estate was taken over by Bishop Neville in 1443 and passed into the ownership of Kepier Hospital, a wealthy hostel for pilgrims to Durham Cathedral, part of which is still standing today and mentioned earlier in this book. The hospital was dissolved around 1545–46 and the whole estate was bought by John Heath around 1568–69 and passed through the family until in 1630 it is believed a fourth John Heath laid out the garden complex still in evidence today. The estate remained with the family until mid-1600 before passing in marriage to the Durham MP John Tempest, but the Tempest family moved to Sherburn Hall as their main premises in 1719. The site remained in use by the family and the garden was maintained. In 1787, William Hutchinson stated that the gardens were a place of 'public resort, where concerts of music have frequently been performed in summer evenings ... The gardens are open all summer for rural recreation.'

By 1748 the gardens were leased as a commercial nursery. Not long after this the manor house at Old Durham was demolished and in 1794 the gardens again passed by

marriage to the Vane-Tempests, then to the Vane-Tempest-Stewarts, the Marquises of Londonderry. Sometime in the early 1800s a house in the garden became a pub called the Pineapple Inn, but due to continued unruly behaviour, it lost its licence in 1926, and from this time until the 1940s it was used as refreshment rooms. The site was sold to the Hopps family in the early twentieth century but after the Second World War the gardens gradually fell into decline and disrepair.

A member of the Hopps sold part of the land to Durham City Council in 1985 and began an annual conservation and restoration programme. This work included three years of archaeological excavation to ensure authenticity of the restoration work. In 1998 the gardens were complimented with seventeenth- and eighteenth-century fruit trees, shrubs and plants, all based on the writings of contemporary clergyman and North Yorkshire gardener William Lawson.

In 1998 the national importance of the gardens was recognised by their inclusion on English Heritage's Register of Historic Parks and Gardens. In 2010, the Friends of Old Durham Gardens, working with Durham County Council, was established to ensure the gardens were maintained for public enjoyment and continue the tradition established over 300 years ago.

Old Durham Gardens. (Photo by kind permission of Robin Airton)

Durham Cathedral.

Prince-Bishops

The County of Durham is also known as the 'Land of the Prince-Bishops' due to the extensive power the appointed bishop held within their 'County Palatine', and because these powers were sanctioned by the new Norman overlords, they could be called kings of the north. The bishops of Durham had the power to hold their own parliament, raise their own armies, appoint their own sheriffs and justices, administer their own laws, levy taxes and customs duties, create fairs and markets, issue charters, salvage shipwrecks, collect revenue from mines, control the forests and mint their own coins. They ruled like a northern king and resided in their castles or palaces at Durham City and Bishop Auckland.

Though there had been bishops of Durham before the Norman Conquest, like Aldhun, Edmund and Eadred, it was the first Norman Bishop of Durham, William de St-Calais, who was appointed by William the Conqueror in 1080. William I had come across William St Calais when he was still the abbot of the Monastery of St Vincent in Le Mans, France, and was considered a strong leader who would be perfect as the head of the County Palatine of Durham. After the Northern Rebellion and invasion by Malcolm III, King of Scotland, the north had been put to the torch during the 'Harrying of the North'. Durham was considered a separate state and a defensive 'buffer zone' sandwiched between England and the often dangerous Northumbria-Scottish borderland.

Below is a list of the bishops of Durham and some commentary about their significance or from other positions they were transferred:

> Aldhun (995–1018) was the Bishop of Lindisfarne and legend credits him as the one who 'determined the hamlet of Dunholme was to be the final resting place of Saint Cuthbert' and the 'city of Durham gradually arose from this influx of a pious society'.
> Edmund (1021–41)
> Eadred (1041–1042)
> Æthelric (1042–56)

Æthelwin (1056–71) was was the last Anglo-Saxon Bishop of Durham and marked an important change in the history of Durham. His death marked the beginning of the period of the Prince-Bishops.

William Walcher (1071–80), born in Liege, was the first non-English Bishop of Durham and also held secular powers. Walcher was a weak leader and was unable to prevent a Scottish invasion, which led to extensive plundering, causing tremendous damage. Eventually after much internal wrangling the Northumbrian people rose up against Walcher and killed him.

William de St-Calais (1081–96) was a Norman bishop, the first to be appointed by William I

Ranulf Flambard (1099–1128), a great builder under whose patronage two great British monuments were constructed: Westminster Hall and Durham Cathedral.

Geoffrey Rufus (1133–40)

William Cumin (1141–43)

William of St Barbara (1143–53)

Hugh de Puiset (1153–95)

Philip of Poitou (1197–1208)

Richard Poore (1209–13) the election of whom was supressed by Pope Innocent III as part of his quarrel with King John but was later elected and consecrated.

John de Gray (1214–14) unfortunately died before consecration after further wrangling with the pope.

Morgan (1215–15), whose election was quashed.

Richard Marsh (1217–26)

William Scot (1226–27), whose election was quashed.

Richard Poore (1229–37) was translated from Salisbury.

Thomas de Melsonby (1237–40), who resigned before his consecration.

Nicholas Farnham (1241–49)

Walter of Kirkham (1249–60)

Robert Stitchill (1260–74)

Robert of Holy Island (1274–83)

Antony Bek (12841310), mentioned earlier in this book, was also the only English bishop to hold the post of Titular Patriarch of Jerusalem from 1306 to 1311.

Richard Kellaw (1311–16)

Lewis de Beaumont (1317–33)

Richard de Bury (1333–45)

Thomas Hatfield (1345–81)

John Fordham (1382–88) was translated to Ely.

Walter Skirlaw (1388–1406) was translated from Bath & Wells.

Thomas Langley (1406–37)

Robert Neville (1437–57), born at Raby Castle, Staindrop, County Durham, was the son of Ralph de Neville, 1st Earl of Westmorland, and Joan Beaufort.

Lawrence Booth (1457–76) was translated to York.

William Dudley (1476–83)

John Sherwood (1484–94)

Richard Foxe (1494–1501) was translated from Bath & Wells, and later translated to Winchester.

William Senhouse (1502–05) was translated from Carlisle.

Christopher Bainbridge (1507–08) was translated to York.

Thomas Ruthall (1509–23)

Thomas Wolsey (1523–29) was Archbishop of York but also held Durham in commendam (meaning he held the post until a suitable candidate could be found).

Cuthbert Tunstall (1530–59) was translated from London. The Reformation happened during his tenure.

James Pilkington (1561–76)

Richard Barnes (1577–87) was translated from Carlisle.

Matthew Hutton (1589–95) was translated to York.

Tobias Matthew (1595–1606) was translated to York.

William James (1606–17)

Richard Neile (1617–27) was translated from Lincoln, and later translated to Winchester.

George Montaigne (1627–28) was translated from London, and later translated to York.

John Howson (1628–32) was translated from Oxford.

Thomas Morton (1632–59) was translated from Lichfield. In 1633, when King Charles visited the castle, Dickey Pearson, the bishop's fool, noticed how richly and fantastically dressed the Earl of Pembroke was when he attended the king. It is said he accosted the earl and commented, 'I am the bishop of Durham's fool, whose fool are you?' It is not recorded how this slight was received.

John Cosin (1660–72)

Nathaniel Crew (1674–1722) was translated from Oxford.

William Talbot (1722–30) was translated from Salisbury.

Edward Chandler (1730–50) was translated from Lichfield.

Joseph Butler (1750–52) was translated from Bristol.

Richard Trevor (1752–71) was translated from St David's.

John Egerton (1771–87) was translated from Lichfield.

Thomas Thurlow (1787–91) was translated from Lincoln.

Shute Barrington (1791–1826) was translated from Salisbury.

William Van Mildert (1826–36) was translated from Llandaff.

Edward Maltby (1836–56) was translated from Chichester.

Charles Longley (1856–60) was translated from Ripon, and later translated to York, then to Canterbury.

Henry Montagu Villiers (1860–61) was translated from Carlisle.

Charles Baring (1861–79) was translated from Gloucester and Bristol.

Joseph Lightfoot (1879–89)
Brooke Foss Westcott (1890–1901)
Handley Moule (1901–20)
Hensley Henson (1920–39) was translated from Hereford.
Alwyn Williams (1939–52) was translated to Winchester.
Michael Ramsey (1952–56) was translated to York, then to Canterbury.
Maurice Harland (1956–66) was translated from Lincoln.
Ian Ramsey (1966–72).
John Habgood (1973–83) was translated to York.
David Jenkins (1984–94)
Michael Turnbull (1994–2003) was translated from Rochester
Tom Wright (2003–10) was previously Dean of Lichfield and he returned to academia.
Justin Welby (2011–13) was translated to Canterbury
Paul Butler (2014–present) was previously Bishop of Southwell and Nottingham.

Entrance to the Bishops' Palace.

The gatehouse at the point where the North Bailey becomes the South Bailey used to be listed as the Priory Gateway and was built around 1500 for Prior Castell (1494–1519). The building also incorporates St Helen's Chapel, which is now a muniment room (storage room for historical documents). The building was apparently modified in the sixteenth century when the arch was dismantled and widened to allow the bishop's carriage to pass through more easily. It was later restored by the Victorians in 1860.

The Prince-Bishops needed a fortification to carry out their duties as border guards or Lords of the March and as mentioned previously there may have been a form of settlement on top the peninsula since at least the Iron Age. The first known community was established in AD 995 by the monks of Lindisfarne because it offered a secure site for them to establish a religious order around the remains of St Cuthbert. It is entirely possible the order erected fortifications to enhance the natural defences of the site and further protect it from potential attackers.

We know Waltheof, Earl of Huntingdon, a lord of English/Danish descent, erected a fortification at Durham in 1072. He was allowed to keep his earldom as long as he served the Norman regime, but at this time Durham was part of the greater

Water Gate, South Bailey.

Bow Lane linking Kingsgate Bridge to the cathedral.

kingdom of Northumbria and had gone through a number of earls of Northumbria before eventually settling on Robert de Comines. He travelled north with an escort of around 700 armed men but was completely rejected by the local inhabitants and he along with his men were massacred in just one night. It is said only a couple of his men escaped. This act sparked a revolt against the Normans across Yorkshire and Northumberland, with the Norman governor of York being murdered and the castles of the area attacked. Over the following year or so William I crushed the rebellion in what became known as the 'Harrowing of the North'. Lands throughout the north were destroyed, livestock killed and houses burnt so that 'no living thing could survive', and yet Durham was left unscathed. Within two years Waltheof, who had married William I's niece, was created the new earl and he commenced construction of the castle probably under the instruction and certainly the permission of William I.

The castle was built at the narrowest part of the peninsula so as to offer maximum protection to those inside, and like most early Norman castles, it was of motte-and-bailey design. Initially the raised earthen motte would be surmounted by a timber palisade to function as a lookout post and final refuge for defence. The bailey would enclose all the support buildings including barracks, stables, workshops, stores and living quarters. The exact date the stone castle replaced the timber is not known but evidence suggests the more solid structure followed not long afterwards and probably at the same time as the cathedral in 1093. Though the castle was meant to protect the inhabitants, Waltheof did not benefit for long when in 1076 he was arrested for treason after his association with yet another rebellion against William and he was executed on 31 May 1076 at Winchester.

William Walcher, the Bishop of Durham, purchased the earldom of Northumbria, which highlights the wealth and position the bishops held at this time. He effectively became the first of the Prince-Bishops who were appointed directly by the king (rather than the Pope, which would cause regular tensions between the king and his bishops) and gave him the authority to raise armies, levy taxes, dispense justice and even mint coins. This power meant they were responsible for the defence of northern England with support from other earls, who would muster forces in defence of the realm and would be involved in key battles in history such as Alnwick (1093 and 1174), Northallerton (1138) and Neville's Cross (1346).

In 1080, officers under Walcher's service murdered a Northumbrian noble called Liulf Lumley, a man who was a close confidant of the bishop. This friendship had aroused jealousy among his assailants, who were also close to the bishop. Following this, the bishop agreed to meet with Lumley's family at Gateshead in an attempt to calm the situation and to make peace, but his speech could not be heard over the mob shouting 'slay ye the bishop'. With the violence spilling over, the bishop took refuge in a nearby church, but the mob set it alight and he is killed as he tried to escape. The mob then moved to attack the Norman castle in Durham but the castle held out after a four-day onslaught by the attackers, which led William to send an army north under the command of his brother Odo, who was also the Bishop of Bayeux, and yet further destruction was carried out in the lands north of the Tees.

It is likely following this episode, and during the tenure of Bishop William de St-Calais, that the construction of Durham Cathedral began and at the same time the castle was rebuilt in stone, the date of which is generally thought to be around 1093. The castle continued to be improved upon during the medieval period as every Prince-Bishop made sure the residence was strong enough to repel the Scots and grand enough to match their ambitions. For example, the Great Hall was added in 1283, probably by Bishop Antony Bek, and the gatehouse was rebuilt in the early fifteenth century while retaining the original Norman arch.

The bishopric was continually tested during the Scottish Wars of Independence over the following years and in 1346 a significant battle was fought on the city's doorstep at Neville's Cross. The battle could have gone either way and if the Scots had

won, Durham would surely have been sacked and possibly destroyed as had other abbeys along their destructive route. The next serious threat to Durham was the Commissioners working so diligently on behalf of Henry VIII during the Dissolution of the Monasteries and the cathedral was raided in 1537. Many of the rich takings from the shrine of St Cuthbert were removed to the royal coffers and the monastery was suppressed in December 1539. The saving of the cathedral may have been the incumbent Bishop Cuthbert Tunstall's willingness to accept Henry VIII as Supreme Head of the Church of England and the break with Rome. Perhaps this was easier for the Bishop of Durham, who was effectively appointed by kings and not popes. The cathedral was refounded in 1541 with Tunstall making sure the clergy consisted of the earlier monastic community. Tunstall was later arrested and deprived of his bishopric for his actions but restored upon the accession of Elizabeth I in 1558.

During the turmoil of the English Civil War, Durham was held for the Royalists but did not see any serious action, but during the Commonwealth of Cromwell, the castle was confiscated and sold to the Lord Mayor of London and the bishopric was also abolished. This act resulted in great economic hardship for the city, and the cathedral as well as the castle became dilapidated or, even worse, were looted. Not until the Restoration of Charles II was a new Prince-Bishop allowed to be restored to the position again and it was Bishop Cosin who began to repair both buildings as well as the bishopric. Further modifications were made to the buildings as peace descended over the country and defence was less important as Scotland and England joined in union.

The secular powers of the Prince-Bishops were only rescinded with the Durham (County Palatine) Act of 1836 and the last bishop to hold the post was William Van Mildert. This meant the Bishop of Durham no longer required a castle in the city and would use his other residence at Auckland Castle, in Bishop Auckland. Durham Castle was granted to the newly formed university and the new keep was actually built over the remains of the earlier tower in the Gothic style. The building has been used by the university ever since. Guided tours can be taken around this beautiful building and centre of learning.

Queen's Court, Queen Street, North Bailey

In the North Bailey is a house that is now part of St Chad's College, with an assigned address of Nos 1–2 North Bailey, but it is still known as Queen's Court and now houses undergraduate students in twenty-four rooms. The Grade II listed Queen's Court is of early nineteenth-century construction with Flemish bond brick, with painted ashlar plinth and ashlar dressings. The building has three storeys, six bays and a Greek fret-patterned doorframe with battered pilasters and still inscribed in the lintel above the door is 'QUEEN'S COURT'.

Queen's Court is opposite Owengate, but in the nineteenth century Owengate was known as Queen Street and is clearly labelled on the early eighteenth-century maps. The North and South Baileys are regarded as the most historic and perhaps most attractive streets in the city; in fact the architectural historian Sir Nicholas Pevsner described them as the best streets in Durham. The area actually began as the residences of the military who were employed to defend the city from attack.

One famous resident of the area was champion boxer John Gully, who settled here in later life after a very colourful career. He learned to fight after a spell in a debtor's prison in Bristol and had had his debts cleared by a group of wealthy sponsors on condition that he would take on the notorious undefeated champion fighter called Henry 'the Game Chicken' Pearce. John Gully was actually defeated in the match on 8 October 1805, but only after the fight had lasted a brutal fifty-nine rounds. Shortly after, Pearce retired and Gully went on to become the champion of all England when he defeated another renowned boxer called 'The Lancashire Giant'.

Unbelievably Gully not only became a great champion but was also for a while a Member of Parliament and a very successful horse owner who won the Derby on two occasions. He invested some of his winnings in the collieries of Durham including those at Trimdon and Thornley. He died at the grand old age of eighty in 1863 at his house at No. 7 North Bailey, which must be considered another great feat for this man who must have taken a great deal of punishment during his career. His stamina and active lifestyle can be further acknowledged by the twenty-four children he fathered from his two marriages.

Dun cow by the river.

R

Racecourse

By the River Wear, on a flat area of ground and within the Elvet locality, is the Sports Ground also known as the old Race Ground. This open area of ground is now a well-used space for all kinds of sport, including football, rugby and cricket, as well as a popular walking area. The space includes boating houses, pavilions, a bandstand and a fantastic statue of the Durham Cow, also known as the Dun Cow, but many years ago this was a racecourse used for the sport of kings.

Sometime during the medieval era, the land belonged to the Durham Priory and was used to tether and care for the horses of visiting pilgrims to the shrine of St Cuthbert. This would no doubt be a very profitable enterprise. The Prior of Durham is also believed to have set up a blacksmith business here to service the flourishing trade and the area became known as Smiddy Haughs, a 'Haugh' being 'a piece of flat alluvial land by the side of a river'. Later a regular race was contested at the ground called the Smiddy Haugh Stakes and in 1826 was won by a horse called Fama.

Though horseracing was established around Durham in the 1600s at Framwellgate Moor, High Brasside Moor and Durham Moor, Hutchinson refers to an event in

Old racecourse, now a sports fields.

Bandstand by the racecourse.

1694 where it was ordered that certain distinguished gentlemen, 'fix the time when the plates given by the said justices, shall be run for on High Brasside moor in this county'. The exact date for the first races at the Elvet Ground are not clear but are thought to be around 1733 when the Baily's Racing Register first provided detailed results from races held at Durham in July of that year. They mention races being held during Friday 10 to Monday 13 July 1733, and included the Durham Four Year Old 30 Guineas Purse, Durham Five Year Old Ladies Purse and the Durham 50 Guineas Purse as the highlights.

The last race was held at the ground on Tuesday 19 July 1887, but seven years later a new racecourse was opened just outside the city in a field off Strawberry Lane, near High Shincliffe, but these race meetings also concluded before the First World War.

There was also a stone-built grandstand on the Elvet racecourse but it was demolished not long after the last meeting to be held in the late nineteenth century. The stone from the grandstand is rumoured to have been used in the construction of Mount Joy Crescent, near Whinney Hill, and maybe other surrounding buildings too. The track of the racecourse is clearly marked on old maps and is still partly visible in the landscape now as a slightly elevated flat track towards the perimeter of the recreation grounds.

One race meeting in 1873 is recorded as having a crowd of 80,000, and much like today would have attracted travelling shows, as well as people keen to feed and supply ale to the racegoers. The annual Durham Miners' Gala is an event held on the third Saturday of July and could draw over 300,000 people at its height during the early 1900s.

S

Smallpox Hospital – Vane Tempest Hall

The Vane Tempest Hall is hidden away behind Gilesgate and is now used as a community centre but was originally built as a militia headquarters and barracks in 1863. Built of sandstone in a mock castle style, and used as the 2nd Durham Militia Stores, the building is recorded as the only remaining militia headquarters Grade II listed in County Durham.

Vane Tempest Hall entrance.

Built in an L-shaped plan, the building has two storeys with five bays in each wing and a corner octagonal entrance tower with blind arrow slits and a battlement-style parapet. The coat of arms above the door is dated 1863 with a panel inscribed '2nd Durham Militia Stores'. The oak-leaf and acorn moulds either side of the door are exquisitely carved. It has a Welsh slate roof with ashlar chimneys and tall square yellow pots.

In 1884 the building was used as the smallpox isolation hospital for Durham and it is said the barracks stables included a 'dead room' for storing the deceased. In May 1916 the hall was being used by the 4th Durham Scout Group and by the late 1940s the Gilesgate Community and Welfare Association was formed and based in the hall. The hall is a favourite 'haunt' for paranormal investigators with many reported spectral incidents including a soldier who accidentally blew himself up using a cannon on the parade grounds, and apparently on the other side of the barracks grounds wall there is an ancient burial ground. There are also stories of a 'White Lady' who glides through the parade ground wall and walks around the area.

Above left: Acorn detail on Vane Tempest Hall entrance.

Above right: Vennel, Ginnel or Snicket in Durham.

Town Hall and Guildhall

The Town Hall and Guildhall is a combination of different phases of build, from medieval, seventeenth and eighteenth century, to the town hall built in 1851 to the design of architect Philip Charles Hardwick. It is thought the first Guildhall was built on this site around 1356, in the reign of Edward III, and it is the Skinners' Guild (dealt in hides and furs) who claim the earliest date of incorporation in 1327, closely followed by the Grocers', Mercers', Salters', Ironmongers' and Haberdashers'. The early Guildhall was replaced in 1665 and much of this interior remains with wood panelling on the west wall and the Arms of William and Mary above. The Mayor's Chamber adjoining to the north has 1752 panelling and there is a Jacobean chimney piece.

By 1849 the old Town Hall was felt unsuitable for the increasing business of the city and the mayor at the time, William Henderson, suggested the building of a new Town Hall. This was readily supported by the town's inhabitants and tradesmen, and from design to opening took only three years. The new hall was built in 1850 and opened in 1851, modelled on a medieval hall with an impressive hammer beam roof with much carved decoration. The panelled walls include commemorative painted panels and most of the arms of the Durham companies are still found hanging in the Guildhall. The entrance hall, though generally modern, has one medieval head-carved stone corbel, which maybe a surviving part of the old Guildhall.

The city of Durham is thought to have received its first city charter in 1179, during the reign of Henry II, though it was not until 1565 that a second charter was granted, and in 1602 a charter introduced the office of mayor to the city, who was to be elected by the guild members known as aldermen. In 1606 Matthew Pattison, who was the son of a burgess, presented a seal of fine design to the Corporation. The seal is an excellent piece of medieval art depicting a bishop holding a staff in his left hand and a raised right hand as though blessing. Other symbols of office include the mayor's chain, presented in 1870, a mayoress chain from 1901 and a mace. There is also a sword with a scabbard of purple velvet, robes and hats to complete the ensemble.

The buildings are situated at the heart of the city and enhance the historical feel of the marketplace. Durham Town Hall is still the official office of the mayor of Durham and the oldest area of the site is continues to host meetings of the trade

guilds and freemen of the city. The venue is available for private hire for wedding receptions, corporate events and conferences, as well as fairs, concerts and dinners. Unfortunately public access is limited but should you wish to visit or indeed have access to the lesser-known parts of the hall, guided tours can be pre-booked.

Above left: Town Hall in the Market Place.

Above right: Market Place at night.

Eros in the Market Place.

Eros in the Market Place.

University Library, Former Exchequer Building

Chancery and Exchequer courts, which now make up part of the University Library, were built between 1438 and 1457 for Bishop Neville and are fine examples of a building from the era. They are built of coursed squared sandstone with ashlar dressings and a stone-flagged roof with the internals including a central passage to a twelve-ribbed vaulted soffit and various surviving features from the Tudor period and from later in the seventeenth century, as well as some impressive masons marks. The Neville Arms (with the ears removed from the horse's head) are located between the upper windows under a canopy and are now brightly painted.

The other half of the library building is from later in the mid- to late 1600s when Bishop John Cosin founded an episcopal library on Palace Green, and is the first public lending library in the north-east of England. The library collection includes many splendid medieval manuscripts and early printed books. In 1832 the University of Durham was established by Bishop William van Mildert, who handed over a collection of 160 volumes of work, and in order to house the original stock of the University Library, he constructed a gallery within Cosin's Library. In the 1850s Dr Martin Joseph Routh, Bishop Edward Maltby and Dr Thomas Mastermann Winterbottom donated some major collections to the library and to house its growing collection, the library was to be extended and occupied the upper two floors of the Exchequer Building. Over the twentieth century further donations were made to the library including the Sudan archive of papers from after the independence of Sudan and the Bamburgh Library, collected by the Sharp family between the seventeenth and eighteenth centuries.

The Palace Green is a fantastic green space in the centre of the city surrounded by the castle, the cathedral, the library and a host of other historic buildings.

Palace Green.

Café on the Green in the old hospital.

Victoria Inn

When drinking a pint of your favourite beer becomes an experience straight out of history, you know some care has been taken over your environment. The Victoria Inn on Hallgarth Street is described as having a 'traditional friendly atmosphere', but this does not do justice to the sympathetically created interior of this Grade II listed family-run public house. They proudly advertise their open coal fires and the fact there is 'no jukebox, no music and no pool table', but you can expect a fine selection of ales and a traditional drinking experience.

Built in 1899, a date proudly displayed in stone with Queen Victoria's head carved into it above the entrance door and boldly retaining its red-brick façade, the building is of modest proportions but boasts six en-suite rooms available to let. The Victoria has a clutch of awards and is regularly voted one of the best pubs in the country.

Alastair Gilmour of the *Telegraph* was impressed by the selection of whiskies, ales and rows of toby jugs. He also commented the 'timber flooring has been worn so smooth in parts it looks like linoleum, while wood panelling, shelving and mirrors blend with floral wallpaper in costume-drama proportions.'

The reason the pub has been maintained in such order is down to landlord Michael Webster, whose association to the Victoria has lasted since 1974 until he bought the pub from Scottish & Newcastle in 1995 after they had plans to alter it. Modernising and updating were not the future for the landlord and Mr Webster was unwavering in his desire to keep his business in the Victorian style and should be commended for doing so.

He explained to Alistair Gilmour that 'Pub companies pay fortunes to turn their places into something like this,' and it is hard to argue with those sentiments when you see the efforts made by some establishments to achieve this old world elegance.

Every single room is decorated to allow the customer to feel as if they have entered a different era and are encouraged to explore the ornaments, sketches and paintings that adorn every spare inch of the interior. The day we enjoyed the hospitality there was a bar filled with nibbles and guests, and the half-pint I enjoyed (driving) was creamy and tasty. The inn is situated within a short walk from the city centre and is well worth a visit. You don't need to just believe me, as you can follow the advice of CAMRA who voted the Victoria Inn Pub of the Year 2014/15.

V

The Victoria Inn.

Left: The Victoria Inn's back room.

Below: The Victoria Inn bar.

There are many other establishments to visit in the old city of Durham but here below is a list of the hotels, inns and taverns in Durham that are listed in the 1827 *Gazetteer*. How many still survive to this day?

Angel, William Atkinson, Crosgate
Angel, James Smith, Market Place
Artichoke, Thomas Southern, Framwellgate
Barley Sheaf, Joseph Gainforth, Millburngate
Bee Hive, John Hornsby, Claypath
Black Horse, Mattew Stephenson, Back Lane
Black Horse, Ann Strong, New Elvet
Black Lion, William Johnson, Silver Street
Black Swan, William Oliver, Claypath
Blue Bell, Thomas Blagdon, Framwellgate
Board, Joseph Raine, Silver Street
Bowes' Arms, Jemima Morrell, Market Place
Britannia, Michael Usher, St Gilesgate
Buck, George Cumming, Framwellgate
Buffalo's Head, Elizabeth Gray, Sadler Street
Bull & Dog, John Elliott, St Gilesgate
City Tavern, Samuel Mitchell, Market Place
Cock, William Oliver, New Elvet
Dog, Matthew Bee, Framwellgate
Duke Wellington, William Kirton, New Elvet
Dun Cow, Ann Hopper, Old Elvet
Durham Ox, Thomas Johnson, Farewell Hall
Dusty Miller, Sarah Horsefield, Back Lane
Elm Tree, John Jackson, Crosgate
Fighting Cocks, Thomas Lindsay, Crosgate
Florist, John Stoddart, South Street
Fox & Goose, Eliz. Allison, St Gilesgate
Free Mason's Arms, William Wilkinson, New Elvet
George & Dragon, Mary Raine, Sadler Street
Goat, John Anderson, Silver Street
Goat, Isabella Holborn, Market place
Golden Fleece, John Robson, Silver Street
Golden Lion, John Grieveson, Sadler Street
Green Dragon, Rosamond Egerton, Claypath
Grey Horse, Michael Graham, Old Elvet
Grey Hound, Ralph Salkeld, Claypath
Griffin, Elizabeth Liddell, Market Place

Half Moon Inn, Jane Best, New Elvet
Hare & Hounds, Joseph Nattrass, New Elvet
Hare & Hounds, Rt Ackroyd, Hallgarth Street
Hat and Feather Inn, Stephen Horner, Claypath
Hat and Feather, (old) John Smurthwaite, Market Place
Hat & Shoulder of Mutton, Dorothy Keith, Claypath
Horns, John Metcalf, Milburngate
Joiners' Arms, George Greenwell, Hallgarth Street
Jolly Butcher, William Morrow, Market Place
King's Arms, Thomas Fawcett, Market Place
Letters, Matthew Lowes, Silver Street
Letters, Phoebe Douglass, Claypath
Letters, John Thwaites, Claypath
Mason's Arms, Mary Bell, Claypath
Nag's Head, Thomas Hutchinson, Sadler Street
Newcastle Arms, John Forsyth, New Elvet
New Inn, James Ross, head of Church Street
Pine Apple, Jonathon Robinson, Old Durham
Prince Leopold, Jason Theakstone, New Elvet
Prince of Wales, Thomas Welford, South Street
Puncheon, James Graham, Framwellgate-Bridge end
Queen's Head Inn and Posting House, John Thwaites, North Bailey
Red Lion, William Dixon, Silver Street
Red Lion, Robert Ovington, Silver Street
Rose & Crown, Thomas Hackworth, New Elvet
Rose and Crown, .John Jackson, Market Place
Royal Oak, James Cummins, Market Place
Royal Telegraph, M. Noble, Oswald Cottage
Seven Stars, Christopher Carr, Claypath
Shakespear Tavern, Thomas Veitch, Sadler Street
Smith's Arms, John Ellerington, St Gilesgate
Spread Eagle, George Burlison, St Gilesgate
Tailor's Arms, Thomas Thompson, Sadler Street
Three Hearts of Gold, Margaret Best, Church Street
Three Horse Shoes, Elizabeth Thompson, Framwellgate
Three Tuns Inn, John Hammond, New Elvet
Turk's Head, Dorothy Lister, Market Place
Waterloo Hotel and posting-house, William Ward, Old Elvet
Wearmouth Bridge, Jason Taylor, Claypath
White Bear, Margaret Hodgson, Keepier
Woodman, John Moore, St Gilesgate

Woolpack, George Walton, Framwellgate
Wheat Sheaf, William Summerbell, Claypath
Wheat Sheaf, Jane Taylor, foot of Elvet Bridge
X, Y, Z, William Herring, Silver Street

Above: River Wear and Boat House Bar.

Right: River Wear and the cathedral.

River Wear and mill.

Wear, Wardeleau and Wharton Park

The Wear

The River Wear rises in the east Pennines at Wearhead, developing from Killhope Burn and eventually flows into the North Sea at Sunderland. The river passes Stanhope, which is known for the ford across the river, before heading on to Frosterley, Wolsingham, and Witton-le-Wear to Bishop Auckland. The river then flows north to Durham, where a neat loop around a raised promontory gave birth to an advantageous and defensible place for people to inhabit. The fact that the promontory is surrounded by fertile, undulating farmland would also be an attractive proposition for people to settle in the area. The legendary creation of the city is, however, linked to St Cuthbert and the story of the Dun Cow.

A nineteenth-century book describes the river below:

> The Wear does not quarrel with the good fortune that has clouded its once pure air, muddied its whilom clear stream, and disturbed its " tranquil bosom" with keels that no longer depend upon the wind for their coming and going. The wealth that has come to it with peace and the development of its mineral resources and shipping trade is not despised, although it be soiled with honest coal dust.

Wardeleau

In the *Gazetteer* from 1827 the legend is described as, 'they approached the ground where Durham now stands, by a miraculous interposition [as the monkish writers inform us], the carriage on which the body of St Cuthbert, with the other relics was borne, became immoveable, at a place to the eastward of the present city, called Wardeleau.'

Was the story the creation of Bishop Aldhun who decided that the land that lay before him was an ideal defendable spot in a time of great upheaval, a perfect location to protect the legend of St Cuthbert from the marauding Northmen? Did he use his celebrated vision to ensure the holy remains of St Cuthbert were taken to his already surveyed location at 'Dunholme'?

Was Wardeleau the name of the Maiden Castle or Iron Age hill fort that sits above the River Wear, just behind Whinney Hill, or was Wardeleau an already established settlement that now lies undiscovered beneath the cathedral and obviously now lost to history? All these questions still remain regarding the old place names embedded in the words of legend and myth.

The legend in poetry form:

> How when the rude Danes burned their pile,
> The monks fled forth from Holy Isle.
> O'er northern mountain, marsh, and moor,
> From sea to sea, from shore to shore,
> Seven years Saint Cuthbert's corpse they bore.

Wharton Park

Wharton Park was created by William Lloyd Wharton, a barrister, mine owner and chairman of the North Eastern Railway who lived between 1789 and 1867. His family lived at Dryburn Hall, the site of the hospital today and his inheritance included the land to the north of the city where the park and railway station would be built. He had already erected a 30-metre-high obelisk in 1850 on the Dryburn estate as a northern meridian marker to assist with the surveillance of the cosmos. This was a gift he gave to the observatory at the University of Durham.

In 1857 the railway station was built and William decided to use the rough land north of the railway to create a public park that would include a mock castle, which eventually became known as the Battery (due to a Crimean War Sebastopol gun sited here in 1858) and afforded a fine vista over the new viaduct and the city. The park was very quickly popular for events and sports, and many visitors would enjoy the walks in the park before taking a seat to take in the dramatic city views. The park was used as an amphitheatre for concerts and later a tearoom was built for the visitors. In 1860 there was even a balloon ride organised to see the city from above. In 1863, William Lloyd Wharton planted a memorial oak in a special stone-built container, near the North Road entrance, to the memory of Prince Albert. Prince Albert was a well-respected man, known for his charity and encouragement of entrepreneurial spirit and William had the following inscription added to the monument: 'While we have time, let us do good to all men.'

This good man of Durham did not live much longer and died in 1867 and was buried in St Cuthbert's churchyard. The park is a permanent memorial to a man of science, astronomy, athletics, the Durham Regatta and Durham Markets Company. In 1915 the descendants of William offered the park, for a minimal fee, to the city council, who took over the running of the park. A hundred years later the park was closed for refurbishment and in 2016, Wharton Park was reopened by the Duke of Kent. The park is still a well-used space with tended gardens, community art and play parks, the tearooms still do business and the park still retains those splendid views over the city.

Right: The mill.

Below: The mill and Prebends Bridge.

Left: Memorial at St Oswald's Church.

Below: Prebends Bridge inscription.

> GREY TOWERS OF DVRHAM
> YET WELL I LOVE THY MIXED AND MASSIVE PILES
> HALF CHVRCH OF GOD HALF CASTLE 'GAINST THE SCOT
> AND LONG TO ROAM THESE VENERABLE AISLES
> WITH RECORDS STORED OF DEEDS LONG SINCE FORGOT

X

Xtra-ordinary Stories from Durham

Toads in Stones

The stories of toads found alive in stones proliferates in Durham, with one account from 1833 saying some quarrymen near Durham 'found an immense toad alive, imbedded in a mass of stone'. Another tale was remembered from a quarry at Easington in the mid-1700s of stones deep below the surface that were recovered and found to be full of dead and some alive toads. This was further mentioned at Oxford University when men were sawing stone for piers in the garden of the library, and as they cut the stone in half, a live toad was found, and the name of the library at the time was Durham College.

The Palace Green.

Again in 1835 while some workmen were opening out an old pit near Whickham, county of Durham, which had closed for around eighty years, they found at the bottom, '28 fathoms, a live toad, which was presented to John Watson, Whickham. It is still more singular how the animal could exist in the foul air, as the men had to erect a brattice to ventilate the shaft before they could enter.'

Explosive Vet

Veterinary work can be dangerous, as shown in 1834 when there was a serious accident involving a Mr Adamson, a veterinary surgeon from Durham. He was preparing some medicine for a horse that included a quantity of nitric acid and oil of tar placed into a quart bottle, but the accumulation of gas exploded and wounded Mr Adamson in his abdomen where later a large piece of glass was extracted. Two horses belonging to the Hon. and Revd Dr Wellesley were leaving the establishment at the time of the accident and one of them received a deep wound in the thigh from the broken glass, and the servant was thrown against the wall by the force of the explosion.

No. 10 Church Street, a listed mid-eighteenth-century house.

X

Favourite Dog

The family of Mr Robert Jackson, of New Elvet, Durham, were saved from possible harm by the barking and howling of their favourite dog. One night in 1834 this trusty animal saw two clothes horses on fire after the family had retired to bed and astutely raised the alarm, allowing the family to be saved.

Sanctuary knocker, Durham Cathedral.

Explosion

On 30 July 1835 at around half past ten in the morning, the boiler attached to the large carpet factory of Messrs John and William Henderson in Durham exploded with incredible force, destroying walls and scattering fragments of the chimney as well as the factory bell, clock and appendages. Not only was there extensive damage to the adjacent buildings but part of the boiler was blown away and described as 'rising in the air like a balloon' before landing with a loud crash on the opposite shore of the Wear, a distance of upwards of 100 yards. Of the 170 workmen in the building the most severe injuries were confined to only nine people but later three of these died from their wounds.

Gunpowder

Another explosion in 1845 was caused by gunpowder at the shop of Mr Steele, a grocer in Claypath who was in the habit of keeping a quantity of gunpowder on hand that he could sell to colliers and others. A shop boy placed a candle too near to a package containing about 30 pound of gunpowder and it ignited, exploding with a terrible crash, the effects of which were felt in many parts of the city. The windows of the shops and houses in the immediate vicinity were almost entirely put out and from the actual house of the calamity, all the floors and furniture were blown into the street. A young woman called Ann Robson, who lived in the second storey, was seriously injured and the apprentice who had faltered was killed immediately. Mrs and Miss Steele were also buried in the ruins, but were able to be extricated with only very minor injuries.

Monument on river walk.

X

Roman Finds

In 1837, it was reported that a gold coin of the Emperor Nero, described as having 'great beauty and in excellent preservation', was found by a woman while hoeing turnips in a field near to Durham. The full extent of Durham as a Roman settlement is of doubt but the old Durham Gardens are said to be built on the most northerly Roman villa in Britain.

The Count

One of the most celebrated characters from Durham history is Count Joseph Boruwlaski, who was a Polish dwarf who was a native of the province of Pokucia in Polish Russia. He was only 36 inches tall but lived in perfect health before his death at the age of ninety-nine in 1837. He was considered a 'lively genius' with 'engaging manners', making him somewhat a celebrity at the time, which allowed him a handsome income that he enjoyed throughout his life. This extract from an nineteenth-century book describes, 'close by the New Bridge, stands a neat cottage, the residence of the celebrated Polish dwarf, Count Boruwlaski, whose memoirs, written by himself, have lately been ushered into public notice. This gentleman has resided many years at Durham, under the patronage of the cathedral clergy.'

The Count's House.

Whale Bones

In June 1838, restoration work was being carried out in the old tower of Durham Castle for the university when a curious discovery was made. Among some rubbish in the lower crypt several whale bones were found, consisting of about fifteen vertebra, twenty ribs and the lower jaw bones. It was uncovered from a letter written by Bishop Cosin to his steward, Miles Staplyton, dated London, 20 June 1661. There was a whale cast ashore near Easington and the bishop ordered the skeleton to be prepared and placed in the old tower, where it was found. From the form of the jaws the species was assumed to be the great sperm whale, which was quite rare on the British coastline.

Bigamy

Records from the court sessions held at Durham on 29 June 1840 tell of a Robert Taylor, alias Lord Kennedy, who is described as aged nineteen, who was tried and

1820 map of Durham – gaol area.

convicted on a charge of bigamy. Up to the date of his trial, six of his marriages had been uncovered by the police and the number was expected to grow in due course. He was sentenced to two and a half years' imprisonment.

Sledgehammer

In 1842, James Liddle, a foreman in the chain and anchor manufactory of Messrs Edward Lumsdon & Son, Strand Street, Monkwearmouth, was remonstrating with a workman called James Robertson for neglecting his work when Robertson picked up a 6 pound sledgehammer and struck the foreman with a tremendous blow on the head. Liddle was carried home where the doctor found his skull fractured and the 'brain ruptured'. The poor man remained insensible until five o'clock the next morning, when his suffering ended. Mr Liddle was a well-respected man who had been in the service of the company for twenty-eight years and was considered 'one of the best workmen in the north'. Robertson was tried at the Durham Summer Assizes, before Lord Denman, and was sentenced to transportation for life.

Rail viaduct.

1820 map showing the old workhouse.

Sordid Affair

A sensational story from Durham in 1845 occurred on the evening of 10 June when in Church Street a Mr Louis Henry Goule, one of the superintendents of rural police, found his wife in company of another gentleman. He fired two pistols at her, breaking her arm in two places and then attacked the intruder, Mr Walter Scruton, who was the deputy clerk of the peace, with the butt end of the pistol, inflicting considerable injury to his head. Very quickly Goule was taken into custody and taken to the gaol, where he

made an attempt to cut his throat with a penknife. Six days after the attack, Mrs Goule died from her injuries and her husband was tried for murder. Brought before Mr Baron Rolfe at the following assizes, Mr Goule was acquitted on the grounds of insanity.

Ruined Chapel

Just off the A690, close to Gilesgate, are the ruins of the Chapel of St Mary Magdalen, a hospital chapel founded in the thirteenth century but largely rebuilt in 1451. After the hospital was shut down in 1546 the building continued to be used as church, but became ruined by the end of the seventeenth century. The remains of the chapel are a scheduled monument and Grade I listed, and the ruin is surrounded by roads with the best views observed from the pedestrian footbridge over the main road.

Durham seal.

Yellow and Blue, the Colours of the County Durham Flag

The County Durham flag was revealed at a ceremony held at Durham Cathedral on November 21 2013, which was attended by the Lord-Lieutenant of County Durham, Chairman of Durham County Council, the Mayor of Darlington and the Dean of Durham. A competition was held to design a Durham County flag and the winning design by James, Katie and Holly Moffat is derived from the medieval arms of the county, often based on yellow crosses on a blue background but incorporating St Cuthbert's cross.

The Durham City flag is based on a shield or arms that from the information I can find was first mentioned in 1615. The white cross on a black shield is believed to represent St Augustine, the founder of the Church of England, and the overlaid red cross may represent St Oswald, the first Christian King of Northumbria. It is also argued that the arms embody the black cloak and white cassock of the Benedictine monks, who founded Durham in the tenth century, and the red cross was added as that of St George and England. Whatever the true story these two flags now represent the city and the County of Durham.

Above left: The County Durham flag.

Above right: The Durham City flag.

1820 map of the cathedral area.

Zululand

The South African War memorial was built in 1905, and is sited outside the cathedral on Palace Green to commemorate the soldiers of the Durham Light Infantry who gave their lives in the Anglo-Boer War (or South African War) (1899–1902). Celtic in style, the tall cross stands on a square step and is decorated with entwined oak leaves encompassing carvings of scenes from the war. The inscription on the base names all those who were lost in the war due to wounds, disease or were killed in action.

Though the Durham Light Infantry served with distinction in the main conflict, the lesser-known Durham Artillery Militia was also involved in the protection of the Zululand border regions to protect against Boer Commando raids across the border. The Durham Artillery Militia was a part-time reserve unit of Britain's Royal Artillery based in County Durham from 1853 to 1909, and although reservists, they were able to volunteer for active war zones.

Although Zululand was not as such involved in the mainstream of actions during the war, there were a few minor actions on both sides of the border, including an attempt by Louis Botha to invade Natal via Zululand. In July 1900 the militia were moved to Eshowe in Zululand under the command of Lt R. G. M. Thompson and engaged in the prevention of any planned Boer border raids. In September a significant Boer Commando, possibly 3,000 men under Louis Botha, threatened Zululand, and a fifty-one-man detachment of the company was sent to Fort Prospect to prepare defences. The British position at Fort Prospect had been extremely well chosen and fortified with great attention to detail by the command. The militia were supported by thirty-five men of Dorset Mounted Infantry, and all were under the command of Captain A. C. Rowley of the Dorsetshire Regiment.

Early in the morning of 26 September, Rowley was warned by a native that the Boers were coming and within a few minutes the position was attacked by around 500 men. Undercover of a mist the brunt of the attack fell on two defensive positions held by the Durham Company, and although the Boers broke through the wire obstacles and got within 20 yards of the defences, they held out and were able to repulse the attack with the aid of a Maxim gun. The Boers pulled back, surrounded the fort and

Map of the action at Fort Prospect based on Captain Roley's report.

poured rifle fire onto the position, bearing in mind the Boers had already proved themselves as good marksmen and were generally armed with a fine rifle in the Mauser. There was a second attack later in the morning but was driven off again and at the same time a party of fourteen from the Zululand Police under Sergeant Gumbi fought their way through the Boer lines to join the defenders. After around thirteen hours of fighting the Boer offensive lessened and they had withdrawn from the engagement by nightfall.

Thanks to the well-constructed defences, the total losses for the garrison were only one killed and nine wounded. Captain Rowley estimated that the Boer forces had

South African War memorial.

suffered at least forty casualties but Botha reported that only two of his men were wounded, one seriously. One bombardier and five gunners of the Durham Artillery were wounded during the engagement and Lieutenant-General Neville Lyttelton recommended Lt R. G. M. Johnson for the Distinguished Service Order and Sergeant F. Doyle and two bombardiers of the battery for the Distinguished Conduct Medal for their actions, but these awards were not made. The men were mentioned in despatches and later in the war Lt-Colonel Ditmas, Major James Gowans, Capt Hugh Streatfield and Company Sergeant Major O'Neill of the Durham Artillery were also mentioned in dispatches, and Major Gowans was awarded a DSO at the end of the conflict.

Depictions of the war engraved on the memorial.

Statue of William Lloyd Wharton in Wharton Park.

Obelisk erected by Wharton.

Statue of Charles William Vane Stewart, 3rd Marquis of Londonderry, in the Market Place.

Sir Ove Arup, the architect and structural engineer who designed Kingsgate Bridge.

Chapel of St Mary Magdalen.

Fantastic eighteenth-century view of Durham.